INSTAGRAM SECRETS (VOL.3)

How to create
INSTAGRAM KILLER CONTENT

Become an Influencer and build a Business with no money on Instagram

Short social media marketing book

By *Rossitza Toneva*

Text Copyright 2020© Rossitza Toneva

First edition

Table of content

Why you should read this book?

Yes, the content is the most important part of Instagram's success, so it makes sense that a more beautiful photo would elicit more likes and engagement.

You don't need a licensed photographer or designer to create amazing visual content for your Instagram feed. You don't have to pay to get professionally done photos. You can use your phone to get amazingly designed pictures, and then get them touched up with some FREE tools that I'm going to share in this book.

You can check my Instagram profile **@rosyontravel** to understand if you like my style. If the answer is yes, you can find a lot of my secrets in this book.

If you want to get more Instagram followers, you need to pay attention to what your Instagram profile looks like as a whole.

When you think about Instagram, think about a highly visual platform, and generally speaking, successful profiles and campaigns are heavily dependent on eye-catching and engaging images.

Content that is useful and engaging is likely to be shared and cited, attracting more traffic, which is why content marketers should dedicate plenty of time to producing high-quality output that will cut through the noise.

Hopefully, this book will give you the right guidelines.

Now it's up to you to read the next pages.

How can I get money with my Instagram profile?

"The best way to predict your future is to create it." Abraham Lincoln

You have in your hands the first volume of twelve pieces puzzle named "Instagram Secrets". This puzzle includes the following pieces:

HOW to find the right Instagram AUDIENCE?
HOW to Build the Perfect Instagram PROFILE?
HOW to create Instagram KILLER CONTENTS?
HOW to outsmart Instagram ALGORITHM?
HOW to use Instagram HASHTAGS?
HOW to use Instagram METRICS?
HOW to use Instagram DIRECT MESSAGING?
HOW to use Instagram IGTV content?
HOW to use Instagram CONTESTS?
HOW to use Instagram INFLUENCERS?
HOW to use Instagram AUTOMATION TOOLS?
How to generate PROFITS from Instagram?

Each element above contributes to growing your Instagram account. You have to understand the secrets of all twelve pieces. That's why I created a set of 12 books. Thanks to this step- by –step set of books, you are going to learn a lot of tricks that nobody shares with you.

Instagram is the main social media platform, with over a billion monthly users, 71% of whom are under 35. So if you want to build a business and your target is millennials, Instagram is the right communication platform.

Keep in mind that there are three major ways to make money on Instagram.

- Work as an influencer to post content sponsored by brands.
- Be an affiliate marketer selling other people's products.
- Become or be an entrepreneur and sell your products or service.

You can learn more about these specific topics in the last book of the collection: Instagram Secrets Vol 12: How to generate PROFITS from Instagram. Become an influencer and build a business with no money on Instagram.

So keep reading all twelve books.

You can find the entire books collection on the next pages:

These are the first 6 books of the collection. Thanks to these first books you are going to learn the basic Instagram tools: AUDIENCE; PROFILE; KILLER CONTENTS ALGORITHM; HASHTAGS; METRICS.

The next image contains the other six books: DIRECT MESSAGING; IGTV CONTENT; CONTEST; INFLUENCERS; AUTOMATION TOOLS; PROFITS.

So once you read through, this set of 12 books I am convinced you are going to become a real Instagram expert. Make sure that you read and understand each book before you move to the next one. You will quickly see that all book strategies are connected. Only when you get the whole picture you can fully understand how to create your Winning Instagram strategy.

Think that thanks to Instagram you could turn your passions into money and build a business, but before you must know all the Powerful Secrets.

Growing your Instagram following requires consistent commitment and dedication. You will not get the results you are looking for if you are not working and build your Instagram page every single day. So you need to think about:

What you are looking to get out of Instagram?

Why are you making an Instagram account?

What kind of goals do you want to achieve with your Instagram account: follower growth, brand awareness, or just revenue?

All my short step by step guides have a section, named Homework task. So take your time to write down your ideas. I am going to help you to clarify your ideas guiding you step by step.

The homework section is really important because it offers you the opportunity to understand what to do in this first stage of the work. Try to experiment with all the ideas that you write down in the Homework section, using your Instagram profile. When you write down your ideas you automatically focus your full attention on them. Remember that you have to experiment.

Before we start I would like to give you a special bonus - the opportunity to get one of my books for free. Send me an email at rtineva80@gmail.com. Please indicate the name of the book that you bought and the day. Send me the name of the new book as well.

Remember that you can contact me for one to one Skype session as well

Please do not forget, if you enjoyed this book and found some benefit in reading it, to post a review on Amazon. Your feedback and support will help me to greatly improve my writing craft for future projects. And make this book even better.

In this specific short guide, I'll discuss in-depth tactics on how to create Killer content.

Let's get start!

Introduction

You have probably already heard the phrase "Content is king!" but do you understand what that means and how it impacts your Instagram account? Providing valuable content regularly has proven to be a challenge, even for the most productive instagramers.

When it comes to Instagram growth, it's simply not as easy to get more Instagram followers in 2020 as it was years ago. So if you want to stand out and get more followers on Instagram, you have to work smarter and harder.

Your feed is the first opportunity you have to make a great impression and entice people to hit the "follow" button. And since your Instagram profile is becoming as important as your homepage, you want to make sure it looks on point.

When someone visits your Instagram profile, they will decide in seconds whether or not to follow your business.

How do they make that decision? By quickly scrolling through your feed, reading your bio, or clicking on your stories highlights.

You must have a great Instagram profile photo, an effective Instagram bio, active stories, and coordinating cover photos for your highlights to attract more followers.

To get tips about how to create a perfect Instagram profile and Bio check my book: Instagram Secrets Vol 2: HOW to Build the Perfect Instagram Profile. Become an influencer and build a business with no money on Instagram. (Short social media marketing book).

Remember that one of the most important secrets of Instagram is named - the consistent activity.

Thanks to this book you will learn everything you need to know about Killer Content.

This guide is going to add one more piece to your puzzle.

Only when you get the whole picture you can fully understand how to establish an Effective Instagram strategy.

If you have some problem with the terminology used to check out the chapter named: Common Instagram terms you should know".

Chapter 1: How to Create Killer Instagram Feed (FREE applications and tricks to use).

Quality content leads to more engagement. When followers truthfully like what you post, you're increasing your chances of converting them to followers or customers.

Far too often, people think it's just fine to post a few photos or videos and wait for the audience to come rushing in. That's not the case with Instagram. Instead, you have to build a content strategy just like you would for any other communication tool.

Your feed doesn't have to adhere to the picture-perfect, to be successful, it just needs to be consistent with your Instagram profile and target market.

Luckily, it's easy to build a professional-looking feed with a well-curated and cohesive Instagram aesthetic!

Cohesive Content means you have to use **specific Theme**, **Composition,** and **Color** to create your own personal Instagram style. So think that when you're creating a new Instagram account, what's important is to come up with a consistent theme, with beautiful colors that match up. But also, you need to ask yourself what is the story behind your pictures. You need to decide what you want people to visit your profile to see.

It is important to understand the rules of the Instagram Algorithm and I will recommend you to check my book: Instagram Secrets Vol 4 HOW to OUTSMART Instagram ALGORITHM. Become an influencer and build a business with no money on Instagram. (Short social media marketing book).

Let's try to deepen the concept.

It is important to publish photos of the same genre. For example, if I have a travel profile, I have to publish outdoor photos.

Do not change often feed composition! For example, **use the rule of thirds.**

Use thematic colors to recognize your photos (Ex, blue, pink, white). Remember that **Instagram rewards bright photos, with high saturation and a predominant color.**

I would like to help you to clarify your ideas on how to organize your posts and to answer some of the most common questions with the next chapters.

How to create a killer post?

The elements of Killer Feed are four: **Quality picture**, **Killer caption**, **Location tag**, and **Good selection of hashtags**. In this chapter, we will learn more about the first two elements.

Everything about the Hashtag strategy will be illustrated in my book: Instagram Secrets Vol 5: HOW to use Instagram HASHTAGS, Become an influencer, and build a business with no money on Instagram.

IMAGE SECTION

When it comes to creating your posts, you can keep this pretty simple.

The first thing that you want to concentrate on is finding a high-quality picture to showcase. Remember that the first thing people are going to see when they come to your page is that picture. You want to go with one that is relevant, high-quality, and engaging, and attractive so that your potential customers and followers are drawn into it the moment they see it. I have nine tips for you below.

1. Use mobile applications to improve the quality of your pictures.

Thanks to applications developed, one mobile phone could be considered a professional photo camera. What you need is a good idea and location. After that, you leave all the work to your mobile phone. In this sub-chapter, I am going to share with you some FREE cool apps that I used to create great content.

You can use apps for the following reasons:

- Text content like quotes;

- Image content;

- Portrait content;

- Previwe app

Text content app

If you have the motivation, quotes, or technical pages like the following Instagram accounts: @quoteoftheday, @quotes @motivation_Mondays, @minds_of_entrepreneurs. You need to use good graphic tolls like Canva and Typeorama.

WordSwag or Typeorama

WordSwag has an Android and iPhone version.
I am using the free version of Typeoreama as well.

Canva

Canva app has a lot of free templates and layouts to choose from, free and high-quality background images or you can just upload your photos.
Canva offers a lot of free templates and layouts to choose from, free and high-quality background images or you can just upload your photos.

The best way would be to use your pictures – either taken by you or from websites like **Pexels**, **Unsplash**, **Pixabay** that offer free high-quality images that don't even require credits. Save the name of these three websites because you can find a lot of free images. These three sites could help you to create high quality content.

Comic Caption Meme Maker

Thanks to this app you can transform your pictures into authentic looking comics! Add word balloons, stickers, and filters. So if you have a Meme page this is the right app for you.

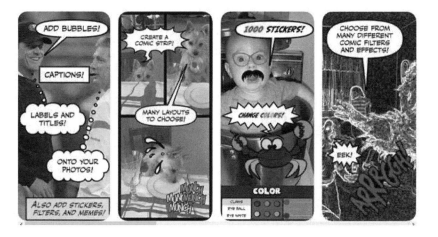

Mematic and Memeto

These two apps are other fast and easy Meme Generator. With only a few taps you can add captions to any pictures and share them with your friends.

Image content app

If you are a travel, a beauty, or a fashion blogger you need to use mandatory the following applications:

Snapseed app

Snapseed is a free application that could download on your mobile. You can see a few highlights of this application underneath:

Above all else, the application has an auto-correct tool, which makes a few changes in the image completely all alone.

This free, completely useful application is accessible on both Android and iOS permits clients to flex with a lot of alternatives to decorate pictures. Snapseed is profoundly evaluated due to its instinctive interface that empowers clients to play with different filters and effects.

The tools are Glamor Glow, Drama, and Retrolux, which can be applied with varying intensity. I use personally Pop and Accentuate filters.

I use the HDR tool; you can find the HDR tool in the "Tools section".

 I would like to explain to you btter how I am using the HDR option better.

Step 1: Load your picture in the Snapseed app with the "Open" option.

Step 2: Tap "Tools".

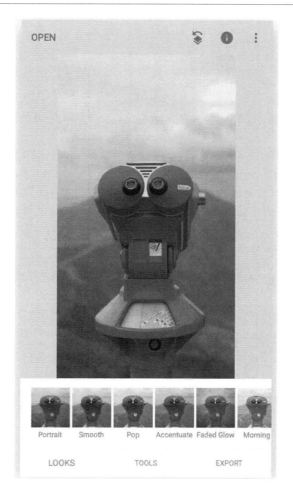

Step 3: Tap HDR.

Step 4: I am using the "Person" Filter, not Nature because is more natural.

Step 5: The magic is going to happen and your picture is going to be more attractive ☺.

Step 6: Press the "V" sign to save all picture sets.

Step 7: Press the "Export" button and Save the picture in your picture gallery.

Step 8: Tap Set up Option and check if the Format of the picture is 100% JPG.

You can use the "Looks" section filter "POP" and after that to use the HDR option to get more colorful images.

Note that you are going to lose your original picture colors when you use the Sanpseed app.
The app offers a very nice Free Tutorial for all new users.

I think this free application is a valid solution to make excellent pictures.

LightRoom app

Lightroom is super powerful when it comes to editing and enhancing your photography, and you can download and use the mobile app for free.
You can use Pre-sets that LightRoom offer I like "Colorful pre-pre-sets " in particulary "Ligh" filters.
If you want to learn how to create your personal presets. I can offer you my experience You can contact me on the following email: rtineva80@gmail.com.

I recommend creating a cohesive Instagram feed is to use the same 1-2 filters or presets on every photo. This makes it super easy to ensure that all your photos go together, and it also cuts down on editing time
A lot of influencers use the VSCO application as well; the application costs 21 euro per year. You can use the option HSL that makes more colorful your pictures.

Instagram app

Do not forget that Instagram offers very nice Free filters devolped by users. I would like to share with you some filters that use:
@danieleconte1993 (Sunset Vibes)
@sem05x_ (Filtro Colori)
@alegio98; (Indie Kid)
@svedese_; (IdenHour)
@aw.samu.(Aesthetic)

It is very important to learn how to find these filters on Instagram. So I just want to list all steps because each month you can find new proposals that can help you to create attractive pictures and videos.

Step1: Go to your Instagram Camera. You have to tap the "+" sign as indicated in **picture 1.**

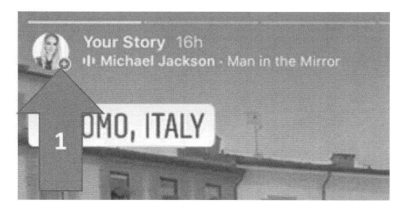

Step 2: Open your Instagram camera you are going to find different filters as indicated **in picture 2**.

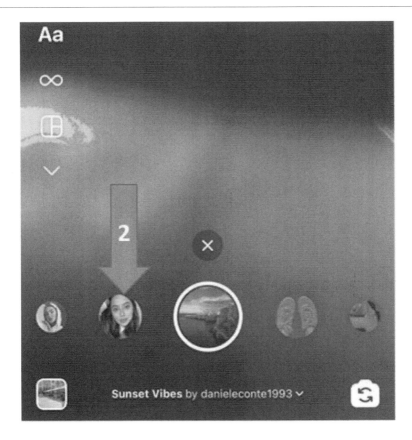

Step 3: Scroll to the end of all the filters to where it says "Browse Effects" or you can find "browse lens".

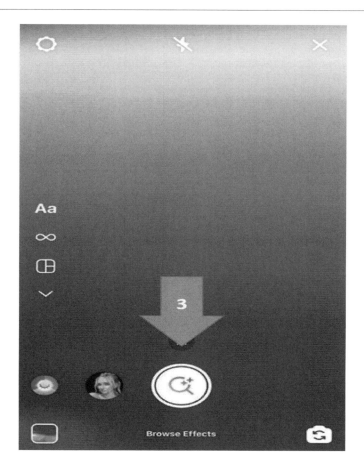

Step 4: Tap on the Browse Effects button, and then go to the upper right-hand corner in the Effects Gallery to tap on the magnifying glass that'll bring you to the search bar.

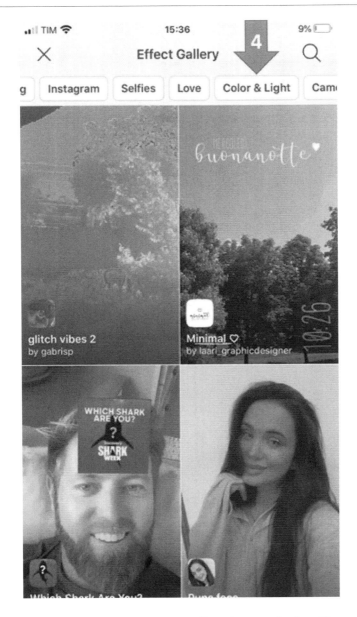

You will find a list with more application tools in **Chapter 3: How to create appealing Story content?**

So keep reading this book you can find more tips in the next pages.

Portrait content app

If you have a beauty page, or you are a model you need to use the following apps.

Face app

FaceApp is the perfect application for your Selfie Image. You can improve your face look thanks to artificial intelligentce.

The app is free to download and use, but there is a paid version as well. The basic version has 21 filters and the Pro version has 28 filters.

The cost of the monthly subscription is $3.99, the annual subscription at $19.99, and the life-time license at $39.99

You can use

How to use Faceapp

Step 1: Install Faceapp from App Store or Google Play

Step 2: Open the app.

Step 3: Click a selfie or choose a picture from Gallery

Step 4: Chose a filter such as " Kiss"

Step 5: You get to see your new selfie.

Step 6: Save it or share it on social media.

Facetune2 app

Application for Selfie Editing Facetune2 is the next generation of the award-winning Facetune app, complete with a new, amazing collection of the best pro retouching.

Facetune2: Best Selfie Editing ⊟
Beauty Camera & Photo Editor
Lightricks Ltd.
#21 in Photo & Video
★★★★★ 4.5, 100.3K Ratings
Free · Offers In-App Purchases

Screenshots iPhone iPad

Snapchat

This app is an amazing tool for FREE beauty filters.
These filters would slim faces, smooth skin, widen eyes, and more controversially, whiten skin tones.
Have you never used Snapchat app? You simply open the camera of your phone and turn it round to your face. Once it's facing you, hold your finger down on your face and you'll see rings appear - these rings mean the filters are about to appear. You'll then see all the filers pop up along the bottom, and you can scroll until your find a filter that you like it. Simply tap the filter and, it's on your face.
You can save the pictures and the video and load it latter on Instagram.

Instagram app

Instagram offers a lot of nice beauty filters as well. I love the following more natural beauty filters:
Cali Glam : jademunster

Beauty babe: Burchiknika

Preview applications

The Mosaico application is splendid. You can upload photographs you need to add to your Instagram grid to envision it before you post the real feed. It empowers your feed to be all the more stylishly. Furthermore, you can set up your caption and publish it directly from the application.

2. Use bright pictures

Light and brilliant pictures this is the key. You will seldom observe an evening photograph on my account. I like to utilize natural light. The best time of day is early morning or right as the sun is setting. White walls help mirror the light pleasantly, but neutral-colored walls can do a similar job. You can use the application like Snapseed or Lightroom to impove the quality of the picture.

3. Make post-composition

For post-creation, particularly with regards to food posts, **odd numbers work best from a visual point of view**. If you have a shot of two pastries, for example, add in a cup of coffee – it will appear more balanced and aesthetically pleasing.
Additionally, build the composition from the upper left of the edge where conceivable, since this is the place your eye, for the most part, goes first.

4. Do not use an excessive number of subjects

Taking photographs from a distance or making a reasonable piece of room around the subject you are shooting will make for a well-curated capture. An excessive number of subjects in a single photograph can begin to look muddled, particularly once you add it to your tight-fitting Instagram grid.

5. Follow the Rule of Thirds

This is the first rule learned by biginners photographers. This rule gives you four lines that represent the best locations for elements in your shot. Positioning the main object of your shot in the intersection or along the lines offers more balance to your picture.
Adhering to the Rule of Thirds is a simple method to carry enthusiasm to your Instagram feed – it's utilizing the 9-square grid on your viewfinder to create the photograph. The Rule of Thirds, weighing the composition in the left two-thirds of the image. It's much more visually appealing than having the subject perfectly centered from all angles.

6. Use Multiple Photos Post

There was a period in the not so distant past when you could just post one picture or video for each post on Instagram that time is a distant memory. Today, you can post numerous photographs in a solitary post. In this way, when you take photos of different products, you can have them all in one post.

This feature saves your time and effort as well as that of the viewer. They will only need to swipe left and see the images.

You can have pictures with a similar idea together for more prominent simplicity of navigation.

Click on the plus sign, to begin with then tap on 'add multiple' on the bottom right.

Pick the photographs you need to post and afterward post them at the same time.

7. Use Video Feeds and do not forget about Cover Thumbnail

When you are posting videos on Instagram, you do it with the hope that it will have multiple views. You want to come back to a ridiculously high number of views. One thing that determines how many people watch your video is the video thumbnail.

The thumbnail tells a user what to expect from the video. Sometimes the very first second of your video may not make a user feel the need to watch the video.

Maybe there is a specific shot that you are sure will create interest in the viewers. Instagram has got your back on this. You can change your cover shot and pick any frame from your video.

The best tips that I can give you to use more often Reels or IGTV and do not forget the previw section of this video in your feed. Instagram is pushing Reels and IGTV videos these days.

8. Use thematic or predominat colors to recongnize your style

Note that the three key elements of a successful Instagram content strategy are the following:

a) **Choose a color palette.** Integrating your brand colors into your feeds is the easiest way to build a consistent-looking Instagram theme. Here's a quick example from **@Nike** which uses black, one of its brand colors, once in every row of the feed, or **@Pinkorgvsm** which uses Pink as color.

My Instagram theme is colorful images @royontravel.

You can check these 3 profiles to get better the tip.

b) Shoot in the same light

Content based on temperature might be a little less obvious than the color palette, choosing a warm or a cold tone for your photos is a great way to build consistency.

Applying warmer shades will give you yellow undertones, while cooler colors will look slightly bluer.

So keep in mind:

- Yellow tones are Warm.

- Blue tones are Cold.

Some influencers always shoot in daylight to make sure that the pictures have the same temperature.

Another nice trick is to shoot in daylight and always try to have something white on the background, for the photos to match better.

If you take your pics during a different time hourse of the day, they will feel different. You don't want that. What you want is to achieve a consistent feel for the whole Instgarm feed.

c) Edit similarly

Once you've shot your photos with the same lighting, you need to edit them the same way to achieve that consistent look.

Most influencers and brands on Instagram use apps like Lightroom or Snapseed as indicated in this chapter.

Remember to use two or three maximum fliters for your profile. Please note that 60% of top –performing brands are using the same filters.

d) Use High saturation colors.

High saturation colors give more colors to the pictures. So try to use this opption as well.

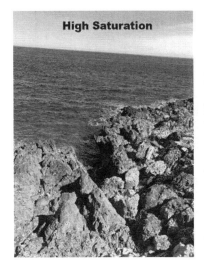
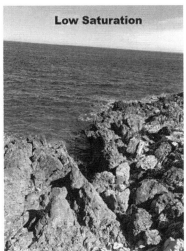

e) Build your Instagram theme from posts that have proven to drive higher engagement.

Take a look at the last feed from your Instagram profile.
Separate your pictures into categories (e.g. people, nature, food, cityscape, product, etc)
Calculate the engagement rate that each picture from each category gets. For your future posts try to offer more photos with them that had a higher engament rate. For example, all of my posts that have myself in them have highr engament rates. The fact is, that's where my highest engagement lies, as opposed to food or other kinds of lifestyle shots. So I know that people like my personal picture more then food or lansacpe onece. You should do your audience research and know what kind of content your followers like to see
I have prepared a very nice method of Feed analysis in my book: Instagram Secrets Vol 6: HOW to use Instagram METRICS. Become an influencer and build a business with no money.
Anyway, quality always comes over quantity for me! And I am always looking to anlayise and to create a nice post.

The last tip is don't post the same type of thing over and over again. Try to rotate your posts for variety I categorize my pictures into selfies, food pictures, landscape shots, and family shots. It's a rotation. For example, if I post a selfie, I don't want to post a selfie right after that. So I'll post a selfie, I'll post a landscape shot or food picture, and I'll keep that going.

CAPTION

What is the Instagram caption?

An Instagram caption is a written description or explanation about the Instagram photo. The caption is the text that you create for your pictures. Instagram captions can include emoji, hashtags, and tags. Here's an example of an Instagram caption:

View Insights Promote

Liked by **elena_d___ mina_love** and **others**

rosyontravel I really love the quote of St.Augustine
(christian bishop and theologian): The world is a book and
those who do not travel read only one page 😊. If you
share this quote tag one your friend. #travelcommunity
#aircrafts #lufthansa #sky_lovers #christian

View all 26 comments

You don't want all of your descriptions just to be a few lines long. Some copy can create a story to go with the picture, others may be short, and plenty will be somewhere in between. Just make sure the copy goes with the picture that you are presenting and that it can engage the customer as much as possible. The caption should provide context for photography, inspire your followers.

A good thing to do with the description is to ask the customer a question. You may ask them what they would like to see with some of your products, what their favorite product is, some of their favorite things to do during the holidays, and so on. Find some way to get the customer to interact with the post, which increases engagement and visibility for your page.

Another element to include is a call to action. You always need to include this on anything that you do with your Instagram page. Once the customer has admired the picture and read through your description, what is it that you want them to do next? Do you want them to comment on something? Do you want them to check out your website? You can choose what you would like the customer to do but make sure that it is included in your call to action at the end of the description.

I would like to share with you a shortlist of Content ideas that you can use in your capture:

The behind-the-scenes caption. Instagram is a great platform for behind-the-scenes content. A lot of influencers explains how their products or service are made in their captions.

The informative caption. General Electric's Instagram captions, for example, are full of compelling facts about science, nature, and company initiatives.

The instructional caption – For example step-by-step cooking videos with the recipe itself.

The contest or giveaway caption - There are few things on Instagram more appealing than the promise of free stuff. If you're running an Instagram contest, promote it in the caption by explaining to the audience how to enter and what they can win.

The storyteller caption. Having a good Instagram caption is important! It can often be the difference between getting lots of likes on your posts and only getting a few. I agree that Instagram is first and foremost, a visual platform. And even with the most recent changes to the Instagram algorithm where Instagram did its best to push users into creating high-quality content, the picture is still the leasing element. However, to keep people coming back, it is important to have quality captions to accompany your perfectly filtered shots. I would like to reassume all the secret rules of the quality caption below.

Secret Rules how to create Killer caption:

1#: Keeps it brief, only the first three lines of a caption will be displayed. So try to be most creative and to create the best caption for your audience.

2#: Keep in mind Instagram limits: Instagram caption character limit is 2,200 characters. How many words are 2,200 characters? About 330 words.

3#: Place the most important words at the beginning of the caption.

4#: Pose a question; one of the easiest ways to get more comments on your photo is posing a question to your followers.

5# Encourage engagement with a call to action.

A good idea is to start with a question or call to action. It will catch your audience's eye and make them want to click on the "show more" button where they can read the whole explanation. Make the first part of your caption super engaging!

A good caption is a caption with a clear call to action.
You can ask people to click on a link in your bio (it's the only clickable link on your profile).
The next thing you can do is asking your audience to answer a question, as I mentioned before, but also ask them to tag someone in the comments section. This will bring new people to your profile. Before you do this, think about the words you need to use to be sure that the people who come would be interested in your offer, and stay on your profile longer than just for a contest or short game.

Another thing, of course, is a call to action for sales. You can dare people to test your product and share their experience in the comments. Or buy a limited series of products, etc.

By using actionable, and not passive words, you can encourage people to react and engage. This is a great step to gain favor with the Instagram algorithm, and the first step to building a real community around your profile.

6#: Don't be afraid to use emoji.

As I said, Instagram is a place for informal communication. Using emojis is a great way to show your current mood, brand personality, and add a blast to your captions. This is also a good way to point out the most important part of your caption by using arrows, fire, or a megaphone icon. Or whatever you want. Have fun using emojis, but remember to not overuse them.

7# Use tags (@) only relevant to the picture.

8# Use the relevant and strategical hashtags.

Make sure that you include some hashtags with your descriptions. These are little tags that go with your description and will ensure that your customers can find you better. Any time someone does a search on Instagram that matches up with your page and matches with the hashtags that you add, you will be in the search results for that.

You can fill up the page with hashtags, which can make it easier for people to find you. The best thing to do here is to think of various keywords that people may use when they are searching for your business or your products, and then use those as some of the hashtags that go with your posts.

You can find more tips on how to use hashtags in my book: Instagram Secrets Vol 5: HOW to use Instagram HASHTAGS, Become an influencer, and build a business with no money on Instagram.

Creating high-quality and engaging posts are critical to seeing success when you are on Instagram or any other social media platform out there. You should take some time to think through the posts that you make to help you come up with the best post ideas possible.

Chapter 2: When and how often should I Post?

One of the main inquiries that you need to reply to before you make your Instagram profile is:

When should I post?

The time of day that you schedule your posts can vary depending on what works best for you. This is a case where you need to have a good idea of your target audience and when they are most likely to be online. For example, if you are targeting stay at home mothers, you may find that posting in the morning and then posting during nap time is going to provide you with the best engagement. But if you are targeting college students, it is best to post later at night when these students are more likely to be awake.

You also want to try and post at a time when your competition isn't posting. If you do this, then you can reach the customer when no one else is there to fight with you for attention. This may be one of the ways that you determine when you will post. Take a look at the times when your competition post and then post at times when they are less likely to be there.

You may need to spend some time experimenting with the times. You can post at different times of the day for a month or so, and then look at your analytics and see when people seemed to respond the best. This will give you a good idea of two or three times when your response rate and engagement seem to be the highest, and you can add that into your schedule.

The important part here is to make sure that you schedule things and become consistent. Things don't always need to be at the exact time, but if you are horrible about posting and go for weeks without it, and then all of a sudden post a bunch of things, you are consistent for a few weeks before dropping off again, your followers will have no idea what to expect from you. Over time, they will stop even checking in, and you will lose all of the hard work that you already put in.

As you have reviewed the above information, a natural follow-on question is regarding time zones. In this case, it is important to understand the time zone that is most prevalent for your target audience. So, if your primary audience is on the east coast, then, you should use the Eastern Time zone and apply it to the directional guidance provided above.

If your followers tend to be geographically dispersed, you may want to create a time zone map that shows the various locations of your audience, and then look for windows of potential overlap so that some of your posts can be multi-purpose, serving more than one-time zone at once. If this sounds complicated, don't fret, as Instagram has built-in tools that can make this a bit easier.

Within your business account, you will have the ability to use Instagram Insights to analyze all your posts. You can consult my book: Instagram Secrets Vol 6: HOW to use Instagram METRICS, Become an influencer, and build a business with no money on Instagram.

How often should I post?

The next question that you may have when it comes to posting on Instagram is how often you should post. This is often going to vary based on the type of business you have, how the other competitors in the industry posts, and more. Also, the number of times that you post is going to depend on your schedule and the types of things that you are trying to promote with your account.

The first thing to consider is how often you need to get the message across. While studies have shown that posting more often is not going to bother the customers that much and it hasn't been linked back to a massive decrease in the number of followers that you have, it is still not a good idea to post every half hour during the day.

It is important to find a good number that you can be consistent with. Usually, doing it at least two or three times a day is ideal for most businesses. This allows them some time to get the news out to customers and can ensure that they are top of mind at least a few times a day. But it doesn't get to the point of annoying customers or not bringing anything of value to the table because you post too often.

Just like with the timing of your posts, you may need to experiment and see what works the best for you. Maybe for one week try to post two times, and then the next week post five times and then do a week at four times. Then take a look at your analytics and see what seems to work the best for what you are doing. If you find that your customers respond the best when you post three times a week, then this is what you should stick with.

Posting is an integral part of running your business on Instagram. There are other features that you can use, but your followers, as well as any potential customers that you may work with, are going to spend the majority of their time looking at your profile and checking out the things that you post. You want to make sure that you post high-quality posts, ones that will grab the attention of your customers and will keep them coming back for more. If you follow the tips that are in this chapter, though, you will be able to write high-quality and professional posts that showcase your work and engage with the customers.

Chapter 3: How to create appealing Instagram story content?

Instagram Stories is one feature that was introduced recently. It lets the user add photos or videos which disappear after 24 hours. This particular feature is similar to the Snapchat app.

What is Instagram Stories?

Once you open the app on your mobile device, you will see red bubbles or circles at the top of your newsfeed. These are the stories posted by people you follow.

You are not limited to viewing the posts once, but you can view them over and over until the 24 hours are up after which they vanish.

You can view an image for 15 seconds before the next image on the story pops up. Tapping on the image and holding allows you to view it for a while longer.

The feature lets you record live videos to post and add as many photos as you would like to the story. Try it out, take an image or two of your products, and add them to your story. This is a great way to promote your product using the feature.

Add relevant information to the image, possibly a geotag to show the viewers your location.

There is a count for your story that shows you the number of views; that way, you can know how many people see your story, and know which stories have more viewers than the others. This helps in plans as you will understand what the viewers like. You also have the freedom to hide your story from some users, such that they won't see it in their feeds.

Instagram stories are a powerful tool that can be used to not only nurture your existing following but also attract new followers into your account or business. When you use your Instagram stories correctly, you can create a significant influx of engagement from your followers, add a personal opportunity to connect with your brand and create a more interactive page overall. On Instagram, people love interacting with the brands that they love and consuming as much of their content as they can, and Instagram offers plenty of ways for followers to do just that. As you upload stories throughout the day, you create the opportunity for your followers to feel like you are genuinely thinking about them throughout the day, which establishes a connection of care and compassion between you and your followers. Not only will this help you maintain your existing followers, but it will also help new or potential followers see how interactive and intimate you are with your following, which leads to them wanting to be a part of your following as well!

The reason why stories work is simple – people are nosy, and they like to know the insider's information. This is not a bad thing either, but rather just a simple human experience where we all desire to be a part of something bigger than ourselves, and we want to connect with those around us to become a part of that "something bigger."

Stories give you a great option to do that because every picture or short clip you share reflects a part of your personal behind-the-scenes experiences. You can also curate your story feed to offer an even more exclusive and intimate feel by purposefully sharing things that will allow others to feel like they are genuinely connected with you through your feed.

The key to making your stories intimate and leveraging them to attract new followers and maintain your existing ones is to make sure that the content you share in your stories is exclusive and unlike anything that you are sharing anywhere else. Be very intentional in sharing things that are more personal and "private" than what you would share on IGTV(Instagram TV) or on your feed itself because this way people feel like they truly are getting that private insight into your account. Instagram stories are already somewhat exclusive because, after 24 hours, they are gone and cannot be viewed again. You can play up that exclusivity by sharing the right content, mentioning things that you shared stories about previously which new followers can no longer see, and even by mentioning outright that your story feed is exclusive. Say things like, "Keep your eyes on my stories because I'll be announcing a piece of exclusive news here first.

The last way that you can leverage Instagram stories is by making story highlights which can enable your new followers to see exclusive tidbits of your previous stories. So, if you are someone who regularly travels and you often share intimate travel experiences with people, such as the restaurants you dine at or the people you meet, you might consider sharing these in your stories. Then, you can create highlights of specific moments from your travels that were most exciting or interesting so that your new audience can glance back through your stories and start feeling more intimately connected with you right away. Leveraging your highlight reels in this way is a great opportunity to show your new followers what to expect, give them that feeling of having known you and your brand for a long time already, and increase their interest in you right from the start.

These stories can be another great way for you to engage with some of your followers.

Remember that engagement with your followers is so important to help them know that you value them and to keep them informed about the products and services that you offer. Also, the more that you engage with your followers, the more likely that you are going to be able to see their stories right at the front of the line. And when they interact with you more, your stories are going to show up in front of you.

There are a lot of benefits that you can get for using these Instagram stories for your future business. But before you use them, you need to have a goal in mind. The reason this goal is so important is that it is going to shape the content that you place in that story. You can choose from a variety of goals, including turning your viewers of the story into subscribers, redirecting people to click on a link to your website, and increasing engagement.

The key here to ensure that you create a story that is engaging is to make sure that there is some structure to it, meaning that it has a start, middle, and an end. The first thing to consider is coming up with a strong start. If your movie starts boring and doesn't catch the attention of your followers, then no one is going to stick around and listen to the rest of it. The beginning of your video needs to be enticing to your viewers so that they stay around to see how it is going to end. A good way to do this is to make a big promise in the first few minutes, so people stick around to figure out what the promise is all about.

An excellent way to start your story could include something like "I'll show you the number one fat-burning food that can keep you fuller for longer, and that tastes great." Or, another opening that you can use that is strong is to list out the types of people who should be watching the story, or who you planned this story for in the first place. So you could say things like "this story is for you if you've been yo-yo dieting and would like to finally get back in shape without spending hours at the gym and without starving yourself."

Once you have a strong beginning to your story, it is time to work on the middle. The middle needs to be high-quality, as well. Since you are only going to have a little bit of time (these stories are concise), you will only have a few seconds or so to fill in the middle.

You may have some room for two or three good tips or some good advice in the story.

And finally, make sure that the story you are working on has a sharp end to it. Give the viewer something to do with the information that you provided them. Always include a good call to action. It isn't enough for you to just tell the viewer to click on your website or something similar. You need to spend some time emphasizing why it is so important for your viewers, why they should click on that link, and why it will benefit them.

Remember, these stories can only be 15 seconds long, and then they are going to disappear after just 24 hours. This means they need to be impactful, even in a short amount of time with them. This is a great way for you to use the stories to help promote your business and reach your customers without having a lot of extra promotional posts cluttering up your profile and making a mess. But you must make good use of your time in these videos, otherwise, don't use them at all.

How Do I Figure Out Ideas for an Instagram Story?

Now that we know a little bit more about these stories, it is time to think of the ideas that your business will want to use in these stories.

To collect the best ideas for stories, do a bit of research and see what other companies in your business have been successful with using. Then you can follow these profiles and see the stories when they come up. You don't want to copy, but you can use these for some inspiration. Some other ideas that you can add to your stories to make your stories stand out to include the following:

Show someone using your product or doing a task related to your business.

Show yourself talking directly to the viewer.

Create a collection of pictures being displayed in a slideshow format.

Create a video clip that has some subtitles that the viewer can check.

Consider some impactful background music.

You may notice that some of the stories that show up with the companies and individuals you follow are a compilation of many different short clips. This helps them make a video that is longer than the 15 seconds per story. But the key for your business is not to try to prolong the video, the key is less is more. When you make a story that is too long, your viewers may lose interest. It is much better to keep the story short and sweet. At most, have two videos together and get 30 seconds, but try to keep your videos as short as possible.

How to Enhance a Story on Instagram?

There are many different methods that you can use to help enhance your stories on Instagram. You can choose to add in text, story filters by swiping left or right, put emoji into the story, and even adding stickers and using drawing tools. All of these are available on the menu for Instagram and are meant to ensure that your videos and stories are even more engaging with the potential customer.

But first, you need to be able to create your own story. To start with this, you should log into the business account that you have with Instagram and head straight to your home page. Look over to the left side of that home page and click on the part that says, "Create a story." After you click here, you are going to choose from a few options. You can either take a picture when you click on the button that says "normal," or you can continuously press on that button to get the video clip to record instead. Then after you have the clip down, you can add in the filters and the other features as they work for the story that you create.

Instagram gives you the option to take some of the pictures that were taken on your phone over the past days, and then turn those into a story if you would like. Click on the camera and then do a swipe up so that you can see a list of all the pictures that you took. Then you can pick from those and turn them into a story that will entice your viewers.

This can be useful for several different reasons. For example, let's say the night before you went to a big event for your business and you want to turn them into a story that will show what the business has been up to and provide some entertainment to your customers as well. This story process from Instagram has made all of this a lot easier to handle.

Use some applications to organize graphically better your Instagram stories

I'll be listing out some of the best apps for Instagram below.

Use Apps to Enhance Your Instagram Stories.

You can find some of the apps that I am using in the next pages to create nice Stories and Reels.

Adobe Spark Post

Adobe Spark Post is an incredible structure application that offers you phenomenal energized impacts in your photographs. The application for Instagram stories supports Android, iOS, and desktop platforms. Other than the incredible impacts, Adobe Spark Post comes bundled with a bunch of estimating choices for whatever substance is taken care of. Preferably, the vast majority pick to change over their photographs into extraordinary 4-second videos with the sole motivation behind sharing on Instagram as stories. Incredibly, there's likewise the alternative to spare select stories to your camera move, making this a standout amongst other applications for making Instagram stories.

PocketVideo

The app conveniently comes available for free on both iOS and Android platforms. To start a new project, you need to tap on the yellow + sign. Then, proceed to select Instagram Story. Those who like customizing videos will find PocketVideo to be quite handy. This is because the app comes bundled with quite several flashy themes for you to play with.

Canva

This incredible app offers pre-built templates to ease the design process.

To get started, you need to select a template of your choice from a huge list of layouts, upload an image, edit, and post. Other creative elements like blurring, cropping, brightness adjustment, and rotating are also available on the app. Extras like arrows, text headers, lines, and shapes are also accessible in the projects section. You can have a look at the app on both Android and iOS platforms.

Canvas offers a lot of templates that you can use to make more attractive your story picture or video.

PicPlayPost

Those who desire to feature more than just a single vertical image or video in their

Instagram stories will find this app perfect for them. The app comes available for free on both iOS and Android. This means that virtually anyone can create photo and video collages on the go for sharing. If you are fully intent on creating Instagram stories, you need to start new projects on the 9:16 ratio. You can choose from various layouts and decide to add images and videos to the available spaces in the collage. If you wish, you can decide to incorporate music into the content.

Remove. Bg

You can use the following Free web sites to create your GIF for your Story or Reel content.

- **Remove.bg** - removing backgrounds is now as quick as clicking a button. You can use this website to remove the background of your picture and videos. You could use your picture or video as you use Instagram GIF.

- **Theinpaint.com** - Magically Remove Objects From Your Photos Online!

Use Instagram templates, stickers, gif, music

You can now add Gifts, Countdown Timers, Quizzes, Pools, and Q&A boxes with a simple swipe of the finger.

Going to the sticker button and choosing them manually before was too hard according to Instagram. To find all Stories templates you have to open your Instagram stories camera and thanks to the swiping up option you can find different nice templates.

Here's what I'm talking about. You can find some examples on the next pages.

Note that all the tools offerd by Instagram and listed below help you to improve your Stories and to make them more attractive and engaging.

What Is An Instagram Story Template?

Instagram Stickers are realistic structures that you add to a picture or video. They are an essential piece of Instagram Stories, assisting you with telling your story by adding to the uncovered pictures/recordings.

For companies and brands, utilizing these Instagram Stickers in their accounts gives their opportunity to connect with their followers. Stickers are an incredible asset to get a saw and direct people to their store or landing page.

As a user with a personal account, stickers are an incredible method to support your following and interact with your followers.

It additionally permits you to get progressively innovative and have a great time with your posts.

If you have over 10k+ followers on a business account, Instagram gives you the choice to link out to your store, item page, or site page by basically "swiping up." So get genuine. Get inventive. Breathe life into your substance and watch your following development.

What are Custom stickers?

Instagram Stickers are graphic designs that you add to an image or video. They are an integral part of Instagram Stories, helping you to "tell" your story by adding to the bare images/videos.

As a user with a personal account, stickers are a great way to boost your following and interact with your followers. It also allows you to get more creative and have some fun with posts. For businesses and brands, using this Guide to Instagram Stickers in your stories not only interacts with your followers but is also a great resource to get noticed and drive traffic to your store or homepage. If you've got a following of 10k+ followers on a business account, Instagram gives you the option to link out to your store, product page, or webpage by simply "swiping up." So get real. Get creative. Bring your content to life and watch your following grow.

I'll show you some of the different types of stickers currently trending, and how to use them.

Music Stickers

You can truly communicate how you're feeling by adding a soundtrack to your story thanks to MUSIC STICKERS.

Even better, when you tap to include a music sticker you'll be brought to a library of music, where you can either scan for a particular tune or channel. The choice to the channel by disposition is a pleasant touch as it permits you to communicate precisely how you're feeling at that given time.

Remember that music is the language of life, and the way that you would now be able to add music to your Instagram Stories makes Stories a great deal more enjoyable.

Poll Stickers

Poll stickers are survey stickers.

They can be included simply like some other Instagram story stickers. Drag and drop on to the picture or video and you'll be given a choice to customize a question and give to your followers to decide on. At the point when individuals see your story, they can pick the response to the inquiry they feel is the correct one. At the point when they tap on a decision to cast a ballot they'll be given moment consequences of the survey up until this point. To see the outcomes for yourself open the rundown of watchers and you'll see who decided in favor of every decision, and which decision has won.

Emoji Slider Sticker

Add emojis to your story is a great way to be creative in interacting with friends and followers.

Use emojis more often because people love them.

Location Sticker

Instagram Geotag is better known as Location Sticker. This sticker is a magnificent way for businesses and brands to get more local exposure.

You can include it on posts to let people know where they've been for lunch. This feature allows Instagrammers to share events, highlight local happenings, or associate with user creators of nearby Instagram stories.

Hashtag Sticker

Hashtag Stickers gave followers the ability to interact with a certain hashtag placed in a photograph or video.

How does it work? When you've snapped your Instagram picture simply drag and drop the sticker and add the relevant hashtag. When published this allows you to tap on the sticker and explore similar posts containing the same hashtag and broadens the reach of the Instagram post. You can find more tips on how to use Hashtags in my book: Instagram Secrets Vol 5: HOW to use Instagram HASHTAGS. Become an influencer and build a business with no money on Instagram.

Selfie Sticker

At the time of writing this book, there are over 450 billion "#selfie" images on Instagram. Selfies have changed the world as we know it. No surprises then, when Instagram presented a Selfie Sticker, permitting you to take selfies and add stickers of themselves to your stories. The advantages of this element are that you can include reaction shots, swap faces for comic value, or feature various sides of your character in your stories.

Donation Sticker

You can use these to encourage people to donate to a selected nonprofit organization.
When people see your donation sticker in your story, they can tap Donate to your selected nonprofit.

Quiz Sticker

Write your multiple-choice question and customize the answers. Your followers can vote and learn whether they got it right.

Countdown Sticker

Count down to any moment. When followers see your countdown sticker in your story, they can tap the arrow in the corner of the sticker to remind them or share your countdown to their Story.

Questions Sticker

People can ask you a question on a sticker. People click the sticker in your story and then type a question for you to answer.

Current Time

Takes the current time from your device.

Weather Sticker

Gives the weather for your location.

GIF Sticker

Adding GIFs on Instagram Stories is easy! When you tap to add a sticker to a photo or video in stories, you'll now see a new GIF option. Tap it and you'll find a library full of hundreds of thousands of moving stickers.

To access the GIF stickers, tap the add sticker button at the top of the stories as usual. From there, select the new GIF option and a library of GIFs will appear.

Here you'll have the option to browse trending GIFs on GIPHY or search its entire library. Once you find the perfect GIF, select it to add it to your photo or video:

Consistently using this feature can add a ton of personality to your Instagram Stories and help you build a loyal following. With **remove.bg webiste** you can create your GIF sticker.

Chat sticker

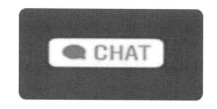

With the chat sticker, you're able to initiate a private group chat (like a group DM) with up to 31 of your followers, but you can choose who joins the chat. And decide how long the group chat will remain open.

Here's a simple step-by-step guide on how to use Chat sticker.

Start using creating your Instagram story as you'll usually — both upload a photograph from your digital camera roll or take a picture inside the app. Add any text, GIFs, or other stickers for your Instagram story to be ready to share. Then upload the Instagram Stories chat sticker — tap the sticker icon on the top-right corner of your display screen and select the Chat sticky label from the list.

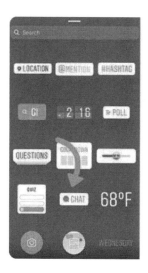
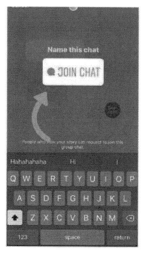
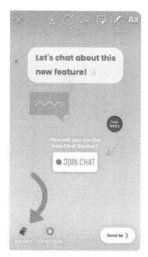

You'll need to add a title for a chat. Once you're able to share it with your followers, tap the "Your story" button on the bottom left corner of your screen, or tap the "Close Friends" if you want to share it with your Close Friends list only.

Once your followers tap the Join Chat sticker, you'll be sent a request to accept them into the chat — you'll need to accept a minimum of one request to start the chat.

You can have up to 32 (thirty-two individuals) friends within the chat (including you as the host), therefore you can choose up to 31 alternative users to join the chat too.

And that's it — you've shared and began your Instagram Stories chat!

The Instagram Stories chat sticker is formed for building a stronger community and having thoughtful conversations on Instagram with your followers.

Don't forget to introduce yourself in the chat — it's nice for your followers to understand that they are talking to a real human behind the profile.

This type of communication will bring in a lot of qualitative insights than a poll sticker.

Always Check Into the Analytics

When you are using things like Instagram stories or some of the other features that come with Instagram, it is vital to spend at least a little time looking at the analytics and how well these stories are doing. You can check out how popular these stories are by clicking on the eyeball symbol that is at the left-hand bottom of your page. This will tell you how many viewers were there for the story and even give you their names so you can make sure to target them later on.

When it comes to these stories, the viewers are not able to comment on them directly. Instead, the viewer either has to engage just by watching the story, or they can choose to send you a personal message. Stories aren't available to be shared, so it is hard for your customers to help you spread the word, and they aren't able to like them either. You will have to look at the analytics often too since these stories are only going to stick around for 24 hours before they disappear.

Check out my book, Instagram Secrets Vol 6: Instagram Secrets Vol 6: HOW to use Instagram METRICS, Become an influencer, and build a business with no money.

Secret Rules how to use better Instagram stories

I created for you some Secrets Rules on how to use better stories feature:

Post regularly, every day, and more than once per day. It is better to split the day into three time zones: morning, afternoon, and evening.

Check Insights to know which type of stories has a good rate of views. You can check the Insight chapter to know further about this topic.

Create short 15-sec content, think about how to create the best and short video content.

Keep the best stories in Evidence, videos posted diapered in 24 hrs., but you have the option to put some of them in evidence to keep them. So use the Highlights tool.

Create Vertical Videos and not horizontal.

Use hashtags #, mentions @, and location stickers in every your story. Don't forget that all the # and @ have to be relevant.

Use applications for editing (Ex: Lumafusion for iPhone, Primal video for Android, Inshot). Only with your mobile, you can create quality video content.

Use different apps (as Canva) for free to create a better graphical setup.

Use all Instagram features, as Stickers, Music, Filters, and questions. You have to think about how to engage for a long time with your public.

Leave a comment on stories of other accounts. Do not forget to engage with other accounts because in this way the Instagram algorithm is going to reward your account and to offer your profile more visbility.

Chapter 4: How to create attractive Instagram Live Content?

You can have live videos on Instagram. These are a bit tricky as they have no room for editing. They stream live as you record them. However, they do provide a great opportunity to promote content, and this tool becomes very poplar during the lockdown Covid period.

Posting these on Instagram would make the viewers more interested in going to the event, as well as creating an interactive atmosphere for them.

The video doesn't have to be perfect. As long as the message is passed, then it has served its purpose. Furthermore, you are given the option of saving or discarding it once you finish making it. If you don't like how it sounds, you can always do away with it afterward.

Sharing live videos tends to create a bond between you and the viewers of the video. Of course, it will all depend on your creativity and relevance. Share something interesting, entertaining, or educative. Take advantage of this feature to improve your account stats.

Note that live video is more appealing to brand audiences: 80% would rather watch live video from a brand than read a blog, and 82% prefer live video from a brand to social posts." So you can find below some secret rules on how to use better lives.

Secrets Rules on how to use better Lives:

Announce that you're going Live.

Interact with comments. **Disable comments** if you don't feel you can accurately respond to people.

Think about the AIM of you Live and what do you want to communicate.

Create a setlist of topics to follow during Live Videos in this way you will be slightly less inclined to make the drunken live story.

Take people behind-the-scenes. People love to go behind the scenes. Fashion brands have been capitalizing on this desire for some time. Brooklyn Beckham recently showed his fans behind the scenes shots of his latest ad campaign for a smartphone brand. More than 891,000 fans have watched his film, and more than 3,000 have left a comment about it.

 Use Interviews, collaborations, and takeovers. Takeovers have been extremely popular on Instagram stories, with brands teaming up to create content for each other's stories; it's predicted that this tactic will transition to Instagram live video as well.

Use Experimental content. This content often catches people off guard and has the potential to delight and shock them.

Try to interview the influencers to increase your followers.

Run a contest that creates a sense of urgency.

Chapter 5: How to create a beautiful Reel video?

Similar to TikTok, Reel lets people create short-form videos edit to music that can be shared with friends and followers and discovered by a huge Instagram community thanks to the Explore page. The Reel is a new way to record 15-second clips set to music on Instagram

I would like to use the official announcment of this tool made by Instagra on August 05th, 2020.

> Today we're announcing Instagram Reels: a new way to create and discover short, entertaining videos on Instagram.
>
> Reels invites you to create fun videos to share with your friends or anyone on Instagram. Record and edit 15-second multi-clip videos with audio, effects, and new creative tools. You can share reels with your followers on Feed, and, if you have a public account, make them available to the wider Instagram community through a new space in Explore. Reels in Explore offers anyone the chance to become a creator on Instagram and reach new audiences on a global stage.

How does it work?

You can identify the Reel icon below. Reel gives people new ways to express themselves, discover more of what they love on Instagram, and help anyone with the ambition of becoming a creator editor.

Reels offers a lot of creative editing tools on the left side of your screen. You can use the fowoing tools:

- **AR Effects**: you can select one of many effects that the Isnatagram gallery offers. Note that Instagram rewards the users that record multiple clips with different effects.
- **Audio and Music**: you can search for a song or audio from the Instagram library. It is interesting to know that you can use your original audio by simply recording a reel with it. If you have a public account your audio will be attributed to you and people can create reels with your audio. This option could help to create viral content.
- **Speed:** you can choose to speed up or down some parts of the video. This cam helpyou with slow motion videos for example.
- **Timer countdown:** you can record any of your clips hands-free thanks to this feature. Once you press record you'll see a 3-2 1 countdown.

- **Align:** thanks to this feauture you can line up objects or pose from your previous clip before recording your next. This can help you to create transitions for moments like outfit changes or adding new friends into your video.

Once your reel video is ready, move to the share screen, where you can save a draft of your reel clip, change the cover image, add a caption and hashtags, and tag your friends. After you share your reel, it will live on a separate Reels tab on your profile, where people can find the reels you've shared. If you also share with your Feed, your reel will appear on your main profile grid, though you have the option to remove it.

Whether you have a public or private account, you can share your reel to your Story, close friends, or in a direct message. If you do so, your reel will behave like a regular Story.

Some secrets tips to use

Tip 1: Share your Reel in your Feed and Story.

Tip 2: Use the Tik Tok app to find more ideas for creative reels.

Tip 3: Use the Inshot app or ImgPlay to improve your editing.

Tip 4: Use popular or trending songs.

Tip 5: Use Align feauture to create original videos.

Tip 6: Follow the tendency of the moment. Trendy dance or jokes.

Tip 7: Use subtitles when you speak.

Tip 8: Select the best Thumbnail or use a photo cover from your camera roll.

Tip 9: Use hashtags in the description or the comment. Try to use trendy hashtags.

Chapter 6: Ideas on how to find the inspirations for your content?

Since we all know that most great stories start with a single great idea, the trick question is: where to find that idea? In this chapter, I would like to share with you some methods on how to find the rights content for your target group.

Use the Google extension, named Keywords everywhere.

It is a fantastic instrument offered by google to find out the things that people are used to searching on the internet. It is a browser extension that shows you keyword information directly in the Google search results. You simply install it, and it works. If you didn't know already, keywords are the words and phrases that people type into a search engine when looking for something online. Unfortunately, this instrument is not free anymore.

Use special Forums as Quora.com and Reddit.com

Online social communities, such as Quora and Reddit, have proven themselves to be valuable gold mines for content creators seeking something that will spark their curiosity and imagination.

Known as "the front web page of the Internet," Reddit is certainly one of the fine locations online to locate useful data and information on pretty much any subject. And the funniest aspect about Reddit is that people tend to neglect how big it is. With over 330 million monthly unique traffic and over 18 billion views per month, Reddit is gigantic.

So, how do you mine Reddit for content ideas then? It's pretty simple: you pick a niche you want to cover, which will be determined by the type of Instagram account, and then simply browse the most relevant subreddits.

Let's say that your niche is Instagram marketing and that you are looking for new feed ideas. You would use Reddit's search bar to enter "Instagram," as you would in any other search engine. You'll notice that one of the search results offered is the r/Instagram subreddit. After clicking on it, you'll be presented with a ton of different threads.

Also, it would help to think like someone who's trying to find a solution to a problem they have. This means searching for the most common phrases inside each of the relevant subreddits, such as:

- Any Suggestion...
- Can I get help...
- Advice on...

Quora web site is somewhat exclusive to Reddit, for the reason that it's a Q&A internet site, and Reddit greater like a big forum, they're comparable in at the least one aspect, and that's the quantity of monthly lively users. Quora is proper at the back of Reddit with an audience of over three hundred million users, which means you should additionally consider it a viable advertising platform. Another similarity is the first-class of content you'll come across on Quora, as the majority of solutions are written by way of either experts or at the least people who have first-rate expertise of the situation in question.

You can browse Quora for content thoughts in two distinct ways. The first one might be to truly enter your keyword. The 2d would be to enter your keyword (we can use the "Instagram" keyword again), and then pick the "Topic" alternative from the list, to be able to take you to the category offering that particular topic. It's kind of like Quora's equal to subreddits. From there, you'll be able to browse questions and solutions, also, to explore "Related Topics," which may be discovered on the left-hand aspect of the screen. What's first-rate approximately Quora is the way its content material is written. While threads on Reddit are commonly made up of quick answers, here they are written as informative and beneficial articles. That makes Quora not most effective a brilliant place to find thoughts, but additionally to expand your knowledge on any of the subjects you encounter. You can even use the content for your studies or reference it in one of your weblog posts. Consistently developing super content for your social media accounts, blog posts and webinars is a major project for each creative and resource prospect. Sharing applicable content material from your website in online communities like Reddit and Quora, or maybe forums is a wonderful advertising hack.

Use the web site Answerthepublic.com

It is a web-based tool. Before you begin brainstorming topics and pitching titles, you need to know precisely what your target audience is asking for, and this is wherein Answer the Public comes in. One of the most effective equipment for coming across what people are trying to find is Google. Answer The Public is, essentially, an automated autocomplete tool; it follows the equal method we've simply outlined to identify capability subjects for content, attempting out different versions of your keywords. You can use the free option to generate quality content. Another tool that you may help you to generate thoughts is https://keywordsheeter.Com/

Use Instagram stories

Try to ask your target audience directly through your Instagram stories. Instagram Stories are an engaging and fun way to start conversations with your followers, you could create a solid relationship with your prospects, and help people get to know your account. You can use the question sticker to ask questions or to let your followers ask you questions. Here's how to use the Instagram questions sticker:

> **Step 1:** Go to your Instagram account.
>
> **Step 2:** Take a photo or video, or select from your camera roll.
>
> **Step 3:** Select the question sticker from your sticker tray
>
> **Step 4**: Type out your question and then place the sticker on your photo or video
>
> **Step 5**: Share your question to your story

Your followers will then be able to see your question and can tap to reply. I would like to share with you some Ideas for Using Instagram Question Stickers.

Use Instagram Polls to Create Short Surveys.

Instagram users love to take polls. Just look at any social media feed and you can see just how many people are giving their opinion on "best movies of the 90s" or just about anything else.

Use Real-Time Engagement.

For instance, if you are a licensed reseller for sports gear or other products, you could ask "How many points do you think XYZ player will score today during Inter – Milan football match?" You can even have a giveaway that you promote beforehand to incentivize engagement.

Use The Instagram tool "How Can I help?"

If you're a freelance, an influencer, or a professional, this may be a powerful approach to build trust with your followers. The best tip that I can give you is to set a time limit on how long you're going to be online. Say something like "I'll be answering questions for the next 30 minutes. Ask me anything you want to know about me" And then answer the questions. This may be an amazingly effective method for constructing credibility as a professional in your field. Here are some examples:

What's your favorite YouTube channel?
What's your favorite song?
Do you have any questions for me?
Who is your favorite celebrity?

Use YouTube.

YouTube doesn't need an introduction since pretty much everyone reading this is familiar with how it works.

However, there is one thing that a lot of people tend to overlook when it comes to YouTube, and that's the fact that it's the second-largest search engine in the world. This means you will practically never run out of ideas for your content. You can look for content ideas in pretty much the same way you would using Google.

Another thing you may want to take advantage of is YouTube comments. Although there is a ton of useless comments, you can sort them based on the number of likes. That way, you'll often come across constructive feedback and suggestions which can be turned into content ideas.

Use Facebook Groups.

You can look up relevant Facebook Groups and join them. There you will be able to find experts and influencers sharing their knowledge, thus enabling you to expand your own, as well as regular users looking for answers to their problems and pain points.

You can use their questions to create blog posts or articles which you will then share within the group. You will grow your authority in the process, as well as drive traffic and spread awareness about your brand or business.

Remember that the content has to be coherent with your Instagram Audience. I would like to recommend you to check my book: Instagram Secrets Vol 1: HOW to find the right Instagram AUDIENCE. Become an influencer and build a business with no money on Instagram. (Short social media marketing book).

Chapter 7: Ways to Source and Create Quality Instagram Content

This chapter will cover exactly how to research images for your Instagram account, where you can find them, and what you need to consider when using them to promote your brand.

You can use these tips if you do not have time to create your content.

So, let's get started!

Create your content using the Instagram templates tool.

Create your own Instagram content the usage of templates. It was once the case that, if you wanted to design a branded picture from scratch, you had to find a designer (or be a professional Photoshop user). Thankfully, in recent times there are masses of awesome websites that provide pre-designed templates you could tweak to fit you with minimal effort. You can use app like Canva or Venngage to get clean and fast templates.

Find high-quality stock images for free.

A great source of high-quality images for your Instagram account is stock image websites. It's amazing how many high-quality and professional looking images you can find in any niche you want. To find high-quality photos you can use the following websites for free:
- Pixabay

- Unsplash
- Pexels
- Stocksnap.io
- Burst by Shopify
- FoodiesFeed

All web sites offer a variety of images for free, and you could find something appropriate for your niche.
 If you have a budget to spend attempt Stocksy. As you get paid pictures, the quality of the images is higher and the range is wider. Just ensure to purchase the appropriate image size bearing in mind the recommended dimensions of an Instagram feed are 1080p x 1080p.

Repost content from Instagram accounts inside your niche.

If you do not have time to create your own Killer Instagram content, you can use the material that other accounts are already doing There's nothing incorrect with reposting content material.
The repost app for Instagram makes it easy to repost pictures & movies on Instagram while giving credit to the original Instagrammer. When you discover something you need to repost, simply copy the percentage URL and open Repost, however first, you have to download the app.

Use Pinterest

And then there is the Pinterest app. Pinterest is an absolute game changer. You can search within your community for great content that would fit your theme. If you need pictures in a certain color palette you can filter your search results by colors or them. And you'll find amazing content that you can mesh into your feed. Don't forget to credit the author if you can.

User-generated content (UGC for short)

User – generated content is an amazing way to get original content for your Instagram feed. This is essentially content that has been created by your users or customers. This can be the best kind of content that you can post on your Instagram feed because it's social proof that your products are making these people happy enough that they want to share it with the world.

☐This type of content will rapidly increase your sales from your Instagram page. But at the same time, it's an amazing tactic to get free content.

The basic tactic for this is if you have a product-based business you can send products for free in exchange for content. Your customers will make the content for you and they can post it on their page too for some extra reach.

User-generated content is so powerful because it shows that people are willing to take the time to create that content. It's an incredibly efficient way to build trust and increase sales because people want to buy from brands they know and trust.

Chapter 8: What are the forbidden contents on Instagram?

Presently Instagram only bans the accounts that have damaged a specific level of Instagram's rules, and there is no way to get around it! Instagram sends a pre-ban warning to users who have abused Instagram's policy and cautions them that they are in danger of being closed down. The warning incorporates that there was a recent violation and how users should act to prevent Instagram from shutting down their accounts.

Luckily, Instagram is making the platform a safer and more supportive place for all its users. The new change in Instagram's ban policy might make parents feel relaxed about their children while they are spending time on Instagram.

There are some exacting principles on Instagram that everybody simply needs to follow. You should know the illegal substance on Instagram that no one should ever use:

Purchasing and selling a gun.

Purchasing and selling liquor.

Purchasing and selling tobacco.

An illegal prescription drug.

Sale of animals.

Online gambling.

Sexual content and abuse.

Hate speech and words.

Blackmailing or harassing someone.

Encourage violence.

Threats of physical harm, financial harm, vandalism, etc.

Encouraging human beings to include self-injury.

Videos of violence.

All the referenced things above are illegal on Instagram. Instagram will remove them, and if the user keeps violating Instagram's rules, the account will be banned.

Chapter 9: Instagram Image Size & Dimensions

Optimizing your Instagram picture length and dimensions used to be very simple. Since Instagram best allowed one placement for photos and videos, all you had to do become pop your content into Instagram, add multiple hashtags, and click on publish.

But with the addition of Instagram Stories, IGTV, Instagram Live, and more, knowing the way to optimize your snapshots and videos for every format may be tough.

In this chapter, you'll find the whole lot you need to optimize the scale and aspect ratio of your photographs and videos. When sharing pics and movies on Instagram, there are two most important things to preserve in mind: aspect ratio and size.

Aspect ratio refers back to the width of a photograph when it comes to its height. It's expressed as a ratio, like 4:5 or 9:16, where the primary digit represents the width and the second digit represents height.

Size refers to the number of pixels that make up the width and peak of your photograph or video. Like aspect ratio, size is expressed using numbers, the first representing width and the second representing peak. In general, Instagram supports images and videos which have a width between 320px and 1080px. What this indicates is that if your photo or video is smaller than 320px, Instagram will amplify it to a width of 320px. And if it's wider than 1080px, Instagram will size it right down to a width of 1080px.When your percentage a photo or video on Instagram, Instagram in reality stores more than one size of that image or video. And the photo that receives displayed on Instagram (each the app and the web) will typically be a lot smaller than the original which you uploaded.

So even if you add a photograph with a width of 1080px, the photo that gets displayed on Instagram can be compressed to a smaller size (generally among 1.81 and 2.24 instances smaller). Even though Instagram does compress your pix and movies, it's always better to share at a high resolution. That way, whilst Instagram compresses your picture, it won't affect the photo excellent. It is important to note that it doesn't suggest you post pix with an ultra-excessive-resolution, like 5400px by 5400px. Doing so will impact your photograph quality negatively. It's also essential to ensure that your pics and videos fall within Instagram's factor ratio guidelines, otherwise, they'll be cropped to shape a supported ratio, which could also affect photo first-rate. Now that we've covered the basics you can find all of the details within the tables below. □

INSTAGRAM PHOTO POST

TYPE	SIZE	ASPECT RATIO
Landscape	1080 X 608 PX	1.91 : 1
Square	1080 X1080 PX	1:1
Portrait	1080 X 1350 PX	4:5

INSTAGRAM VIDEO POST

TYPE	SIZE	ASPECT RATIO
Landscape	1080 X 608 PX	1.91 : 1
Portrait	1080 X 1350 PX	4:5

INSTAGRAM STORIES

TYPE	SIZE	ASPECT RATIO
Horizontal	1080 X 608 PX	1.91 : 1
Vertical	1080 X 1920 PX	9:16

Note that Instagram supports anything from 1.91 to 9.16, but recommends an aspect ratio of 4:5 and 9:16.

IGTV TV

TYPE	SIZE	ASPECT RATIO
Horizontal	1920 X 1080 PX	16:9
Vertical	1080 X 1920 PX	9:16

IGTV videos can be both vertical and horizontal. Vertical videos can have a maximum aspect ratio of 9:16 and a minimum of 4:5. Horizontal videos can have a maximum aspect ratio of 16:9 and a minimum of 5:4.

For IGTV cover photos, Instagram recommends an aspect ratio of 1:1.5 or 420x 654 px.

INSTAGRAM LIVES

TYPE	SIZE	ASPECT RATIO
Vertical	1080 X 1920 PX	9:16

To optimize your photos, videos, Instagram Stories, and more I suggest using graphic free tools like Canva.

Chapter 10: Homework Section

Check the posts and the captions of some profiles that you follow relevant to your niche. Try to select 10 pictures and captions that you like. Try to copy this picture and to improve it.
List the profile that you chose.

Ask your followers what kind of content do they want to see?

Consult some forums and websites to understand better what the people are searching for on the internet. Chapter 6: Ideas how to find the inspirations for your content?

Download app as Snapseed, Lightroom, Snapchat, and Canva. Try to use the application listed. Consult the paragraph Use mobile applications to improve the quality of your pictures.

Think about how often show I post? Chapter 2: When and how often should I Post?

Consult some high-quality stock images to get free pictures and use them in your future feeds. Consult chapter 7 in order to know where to find high-quality stock images for free.

Think about what kind of content you can offer in your Instagram stories? **Chapter 3: How to create appealing Instagram story content?**

Create an Instagram schedule calendar and Instagram content strategy.

Conclusions

Congratulation that you finish one of 12 books of my Serial collection: **Instagram Secrets.**

I hope that thanks to this book you understand that Instagram emphasizes photos more than any other social media platform. With Facebook, there are posts and comments and articles and clutter that might allow followers to skip over a simple photo. But with Instagram, the main event is your photo! It needs to be clean, sharp, and provocative.

What this means is that it needs to be a high-quality photo that makes your followers think. Since people can scroll on Instagram your photos need to stop them in their tracks long enough to engage with your post, read your caption.

Allow your followers to fall in love with your content! We found that it helps to create a theme for your Instagram. Write down a few words that you want people to associate with your account.

Regarding my account @rosyontravel, I hope people glean that it's bright, artistic, and travel pictures. You have to make sure that you are posting items that provide value to your customers, things that are unique and can stand out, and things that relate to or showcase your values.

Thank this book you learned how to create unique and killer Feed, Story, Reel, or Live content.

Other books

I hope that this book added value and quality to your social knowledge. If you enjoyed this book and found some benefit in reading this, I'd like to inform you that you can find in the Kindle store (Amazon) the following short guides that make part of the serial set.

Instagram Secrets Vol 1: HOW to find the right Instagram AUDIENCE. Become an influencer and build a business with no money on Instagram. (Short social media marketing book).

Instagram Secrets Vol 2: HOW to Build the Perfect Instagram Profile. Become an influencer and build a business with no money on Instagram. (Short social media marketing book).

Instagram Secrets Vol 3: HOW to CREATE Instagram KILLER CONTENTS. Become an influencer and build a business with no money on Instagram. (Short social media marketing book).

Instagram Secrets Vol 4 HOW to OUTSMART Instagram ALGORITHM. Become an influencer and build a business with no money on Instagram. (Short social media marketing book).

Instagram Secrets Vol 5: HOW to use Instagram HASHTAGS. Become an influencer and build a business with no money on Instagram. (Short social media marketing book).

Instagram Secrets Vol 6: HOW to use Instagram METRICS. Become an influencer and build a business with no money. (Short social media marketing book).

Instagram Secrets Vol 7: HOW to use Instagram DIRECT Messaging, Become an influencer, and build a business with no money on Instagram. (Short social media marketing book).

Instagram Secrets Vol 8: HOW to use Instagram IGTV content. Become an influencer and build a business with no money on Instagram. (Short social media marketing book).

Instagram Secrets Vol 9: HOW to use Instagram CONTESTS. Become an influencer and build a business with no money on Instagram. (Short social media marketing book).

Instagram Secrets Vol 10: HOW to use Instagram INFLUENCERS. Become an influencer and build a business with no money on Instagram. (Short social media marketing book).

Instagram Secrets Vol 11: HOW to use Instagram AUTOMATION TOOLS. Become an influencer and build a business with no money on Instagram. (Short social media marketing book)

Instagram Secrets Vol 12: How to generate PROFITS from Instagram. Become an influencer and build a business with no money on Instagram. (Short social media marketing book).

Do not forget about my special Bonus. Get one of my books for free just sending me your email at rtineva80@gmail.com.

About the author

Hello, nice to meet you in this virtual space. Now it's time to introduce myself.

My name is Rosy Toneva, and I am a Commercial and Marketing B2B expert for some of the largest European Airlines. I enjoy traveling, writing, snapping pictures. I spend time daily writing and updating my Instagram blog @rosyontravel. I believe in one religion - Traveling!

I love educating and inspiring other people to succeed and live the life of their dream. I often repeat myself: If more than 50% of my brain believes it, it will come true.

I think that social media allows people to interact with others and offer multiple ways for marketers to reach and engage with consumers.

Now I would like to share with you how I started this project.

In April 2019, I decided to test my Instagram profile. I wanted to grow my Instagram account through my two passions, "Travel and Marketing". At the time, my account @rosyontravel had around 560 followers. I wanted to increase my followers in an organic way (no buying fake followers), no huge investing. I just desired to see what I could do by putting forth a conscious effort as a normal person did. It's been an intense four-month experiment of seeing what works and what doesn't. After only four months, I gained 10k loyal followers.

Thanks to a lot of tests I prepared a set of twelve books, named Instagram secrets that you can find on Amazon. The advantage of these books is that they are very simple and do not offer trivial tips. The good new is that I am a normal person like you so you can just check my page and say hello.

You can follow my Instagram profile (@rosyontravel) to get further information and updated news about Instagram.

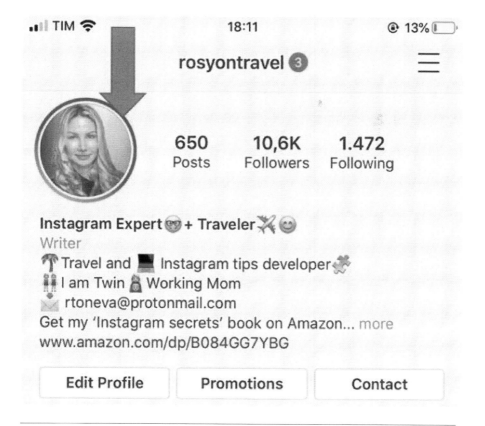

If you want to know more about Instagram secrets methods described in this book, please contact me personally. Send an email to rtineva80@gmail.com or use Instagram Direct messaging.

One last thing

If you enjoyed this book and found some benefit in reading this, I'd like to hear from you and hope that you could take some time to post a review on Amazon. Your feedback and support will help me to greatly improve my writing craft for future projects and make this book even better.
Please post your review if you like this book.
I wish you all the best in your future success

Common Instagram terms you should know

Bio - This is the biography of your profile on Instagram. This is your place to tell the world a little bit about yourself. You can use text, emojis, hashtags, and even '@' mention profiles here.

Mention - This is how you get someone's attention on Instagram. Begin with the @ symbol, followed by their handle or name. If you're following them, you'll find their handle in the first couple of autocomplete options. You can mention someone in a variety of places on Instagram, including in your bio, comments, or even in Instagram Stories.

Tag - Tag is different from Mention. You can only tag a person on a picture or a video. When you tag someone, it will show up in their profile (in the tagged section next to their Gallery).

Instagram Algorithm – An algorithm is a detailed step-by-step instruction set or formula for solving a problem or completing a task. In computing, programmers write algorithms that instruct the computer how to perform a task. Instagram Algorithm is several rules that the application follows to protect her community from spamming users and to set up the company earning a strategy.

Instagram Bots – These are automated profiles masquerading as people. But sometimes, even legit profiles use automated bots (third-party services) to get your attention. If you come across random comments on your posts or a slew of likes seconds after you post a picture, a bot was probably involved in the process.

Business Profile - Instagram offers a simple way to switch from a personal profile to a business profile. You don't even need to be a registered business to use a business profile. And there are many advantages to converting to a business profile. You get access to action buttons in the bio and you get detailed insights from your followers. Plus, using a business profile is the only way to unlock features like embedding links in Stories and adding buy buttons to your posts.

Insights - Once you've converted to a Business Profile, you'll see an Insights button in the top toolbar in your profile. Tap on it and you'll find a sea of useful information. You'll find out what the age and gender breakdown of your followers is, as well as the best time to post to Instagram for maximum engagement.

Explore page - Tap on the Search button from the bottom toolbar and you'll end up in the Explore tab. This is the hodgepodge of everything that's trending on Instagram right now. On the top, you'll find topics, and below, a feed of popular photos and videos.

Home page - The Home screen is the list of activities of all the users you follow. Also referred to as the feed.

Swipe up –It is a feature that allows you to add links to your stories. Now, all Instagram business accounts with 10,000 or more followers can add links to Instagram Stories. Up until recently, this feature was only available to verified Instagram accounts (accounts with sign V).

IGTV - IGTV video is an app that can be used alone or in tandem with Instagram. It's essentially Instagram's answer to YouTube.

Instagram Stories - is a feature within the Instagram app where users can capture and post related images and video content in a slideshow format. In both apps, content is available for only 24 hours from the time of posting. Stories allow the addition of text, drawings, and emoticons to images or video clips.

Instagram contest - is a great way to get more followers, build an engaged audience, and grow your brand. The contest is a promotional scheme in which participants compete for prizes by accomplishing something that requires skill. Although no fee is charged for participating in a contest.

API – The term API is an acronym, and it stands for "Application Programming Interface." The API is not the database or even the server, it is the code that governs the access point(s) for the server. They allow us to go get data from outside sources. To explain this better, let us take a familiar example. Imagine you're sitting at a table in a restaurant with a menu of choices to order from. The kitchen is part of the "system" that will prepare your order. What is missing is the critical link to communicate your order to the kitchen and deliver your food back to your table. That's where the waiter or API comes in. The waiter is the messenger – or API – that takes your request or order and tells the kitchen – the system – what to do. Then the waiter delivers the response back to you; in this case, it is the food.

IP Address - It's a network address for your computer so the Internet knows where to send you emails, data, and pictures.
With this short guide, I'm going to give you a deep dive into how to use Instagram hashtags to increase your followers. Using the right hashtags is fundamental. If you include the right Instagram hashtags on your posts or stories, you will likely see higher engagement than you would if you didn't have any.

Instagram organic follower growth - An organic follower growth rate means that an influencer attracts more followers over time with his or her content, gains more attention, and becomes more popular. The organic growth is based on genuine followers who are honestly interested in the content of the influencer shares.

Printed in Great Britain
by Amazon

63279390R00061